Clouds without heaven

CLOUDS
WITHOUT HEAVEN

POEMS BY

MARY CAMERON

Porcepic Books
an imprint of

Beach Holme Publishing
Vancouver

This book is published by Beach Holme Publishing, #226—2040 West 12th Ave., Vancouver, BC, V6J 2G2. This is a Porcepic Book.

We acknowledge the generous assistance of The Canada Council and the BC Ministry of Small Business, Tourism and Culture.

THE CANADA COUNCIL | LE CONSEIL DES ARTS
FOR THE ARTS | DU CANADA
SINCE 1957 | DEPUIS 1957

Editor: Joy Gugeler
Production and Design: Teresa Bubela

Cover Art: *Madame Cézanne in a Red Armchair* by Paul Cézanne (1839-1906). Oil on canvas, 72.5 cm x 56 cm. Bequest of Robert Treat Paine II. Courtesy of Museum of Fine Arts, Boston.

Canadian Cataloguing in Publication Data:

Cameron, Mary, 1962-
 Clouds without heaven

 Poems.
 "A Porcépic Book."
 ISBN 0-88878-388-4

 I. Title.
PS8555.A5195C66 1998 C811'.54 C98-910855-4
PR9199.3.C27755C66 1998

This book is for Chris

Contents

Madame Cézanne

Who would waste tears upon her? Is she not
The least of our losses, this unhappy wife?

— Anna Akhmatova

Oh, be an apple, and leave out all your thoughts, all your feelings,
all your mind and all your personality, which we know all about
and find boring beyond endurance. Leave it all out—and be an
apple!

— D.H. Lawrence

Peaches

You'd think fruit would blister on this
impossible edge: the sunken peaches
and their mates, broke
with decomposition, the more eaten,
smashed in the teeth for that first
taste, the more wrecks he makes.
She lifts the fruit into
his studio, selects by weight,
approaches with the cloth cradled full.
The fruit, drawn, fall away,
the bruising at her hips and shoulders
ripening to maturity: the mottled paint
reflecting mastery, not sympathy.

Onion

The skin transparent, illuminates
the inside: thank God for lies,
thin, tear-bound, rimmed with ivory.
Out of the dark this thing produced its bitterness.

How did he strip the beauty from her,
once he sketched her blind: every white thing fell away,
and expecting love she tore open, willingly.

Now the split sun passes judgement on her daily,
the arms he drew are spiked, pained from the false
unpinning of her hair.

Fragments of the wife

Then even the worms sang to me
out of the worm holes in the fruit
across the shadowed tables, easels, frames,
 so bitterly, bitterly, this blind body
splits the skin out of sweetness
into a darkened room.

*

Be my love and I
 your love and we'll
enslave each other willingly.

No mastery of will,
 but sure of every mastery of love.

The heart's true spring,
 the new leaves' comforting.

*

Little child in me, small bold one,
have I made you tender?
 Your father is out there,
in the garden, in despair.

Still-life with Plaster Cupid

The weight of the painting
comes to her at night, the Cupid and easel
between child and master.

His small effigy, smoothly
almost without bones, a prick near the apple key.

Nothing left to hold
the bow, the eyes blind globes,

as if he knew,
and onions bitter at its base
a mockery of lost appetite.

Why paint the small blue breast?
Her prayer for a path
out of the barren wilderness.

Madame Cézanne

Why do you pout
and your grey and white striped blouse
bend with your tears?

Even up against the wall your head belies
its glowing crown, your ears
are red-tipped. What of the small

held shadow in your hair?
Your cheeks drawn with sharpened nails,
you look askew, toward the edge

of a painting, some bleak fruit,
your cluttered life: happy woman,
happy wife.

Are you shaded by his resignation, penitent,
housebroken? Who wouldn't turn
and break the lines that keep you mending;

you must not look away
from one intent on changing art.
Darling wife to inspiration, suffer hands

that hold the brush, ignore the mind,
the disciplining spirit. For our sake, silence
is a colour that remakes itself

and colours all the shapes here:
lips, clothes, oval face gleam from the wall
as if this place is all we'll know.

In the Conservatory

Madame Cézanne with a man's
crabbed hands, an unfinished

black dress. You see how the broad face unfurls
in his loneliness.

The flowers more certain in their trailing
from the wall. Roses, unlike her

thinning hair, unlike
the smears of orange on her cheeks,

his burnt sienna, blue,
her turn away from you.

The chair has more solidity than this: waiting,
her eyes already drawn, and hating.

Madame Cézanne in a Yellow Chair

Her body wrapped in rust against a blue
 wall, she leans into the chair
 inside a face already ovalled, cameo-smooth

and this is what she becomes: a sky-blue room
 an inner world, her eyes,
 held up against his fierce

ambition; framed, hanged by a wire, suspended.
 Would she fall through us as cloudless
 as this tilt of head,

become a mask, become our own marred
 face and history?

There is no audience, this is her future view,
 her muddled hands defiant, painting you.

Untitled

In other words, Cézanne plainly felt
no need now to commit.

Madame, as you linger in a doorway
fringed with chamomile and small wild roses

and your smile is for the lover in the corner,
one who knows you,

you think the rustle of your silks could be
an invitation or a prize. But when he sees you,

you come undone before his
terrifying gaze, he shouts you off.

So you learn that each small entry
towards him brings a larger fury

until you hesitate to look into his work
or pause outside his door, although

on autumn afternoons you could decipher
what leapt across his back,

his shoulders, through his hands and found
some small relief reluctantly on canvas.

But what is it to you, your thwarted passion?

Water Maidens, 1883-1885

> *Cézanne had problems overcoming his*
> *shyness towards naked models...*
> *at times he made do with his wife*
> *Hortense.*

The girls shimmer and pale
as though the water where they bathe
has iced them. This is where
a glimpse of death could be to their
advantage, these naked ones beneath the willow fronds,
within the blades of grass:
there is a lake, and its slow pass
against the shore, a sad eternity.

*

Something feathery and fallen from a
branch held gently to the mouth: the willow
slim as brushes on the body.
At times he made do with his wife
and she looked away, and he looked away,
studying the paint. She sees the outside world
a challenge, standing, lying, squatting.

*

And they appear, perfect along a lakeshore,
bodies coloured by the light of grass and leaves,
their bareness like a canvas.

*

Green that covers everything, the watercolour blue
becoming pigeon, out of lime. The light let out
in bursts, their heads align, descend into the wake.

View of L'Estaque and the Château d'If

His collection of distant houses
uncovers a vast span of canvas: blue, white

wave tips, breaking shore, their ochre flat roofs.
With colour, intention, the air is there,

a sense of the wind moving. Walls fall into
a vague periphery, and windows. The slow walk

along roads where globed olives cluster on the branch,
the heat of a cloudless sky holds us

to our hearts, hurls us furious through town or onto hills
watching the sea or some more distant country.

But these are his impressions—a branch
where a canvas sways, behind which she undresses.

Sketching Cézanne

Studying the master, hopeless:
 without the eye of a genius,
 the fuck you of an obstinate, what am I but
student of the unapproachable, the latest copyist?

*

Bloody page, the thick book struck
 by sunlight, scarlet
on a table's edge, the leather raised
 to holy white-wrapped letters,
she knows not what.

Sketches of her and the boy,
 in her confinement, his fear.
He struck out to paint in the hills,
 then he and the boy made pages and bloody
pages of her.

*

He was obstinate, the pig, late
dinners, the unexpected outbursts.

 She made the serious jeer, and the joyous
 banal. A man works in his isolation,
 there is no helping him.

And you wonder why she travelled?

She made him feel small.

*

I stepped into the paintings delicately
as though a polite, invited guest, and then
accused him of misogyny; was a spy in their midst.

*

The apprentice's dream:
for backgrounds of honey, where trees run together
in leaves and teal

against a goldcapped wave of sun,
and these blackened contrasts of man and woman,
imperfections of a certain heaven.

*

I knew the point of this exercise was to
excise the particular in favour of
the real, the underlying apple

of the everyday, but how
will the wife be pleased?

Does she drag through days
in grief, some form of madness?

*

Now she hangs quietly while buildings
frame the skies, and the assault on my eyes is lifted.

Portraits

Inside you opens up vault after vault endlessly.
You will never be finished, and that's the way it should be.

— Tomas Tranströmer

The Cook

No matter from which source—beef, calf,
lamb or pork—the smaller-size tongues

are preferable, he reads while eating
at the long steel table.

Without a tongue, without a wife, what
life? the soft bread torn between his teeth

swiftly brought into his mouth,
chewed and chewed, and moved

around without a sound by his
small tongue, tender

as a lamb. Washed down
with lilied wine.

Scrub the tongue well,
immerse the tongue in seasoned boiling

water: better to be damned
than risk believing in a hell.

And plunge it into cold water
for a moment.

The Son

Monet's bridge of trees with its
illusion in the upper distance
arcs across to another room, where

pine is on the floor, beneath
a subterfuge of oils the wave of brushes
mounts against you. Here the artist

coaxed your father's hands to hold up
instruments of law, the cryptic gestures
of precision: weighed, equations could be

summed, the scales were right or wrong.
But where your sight is drawn, entangled, all
your faithfulness becomes ecstatic hymns to him

who gazes at you, shocked and dumb.

Peasant Holding a Wine Jug

Dark and grinning, he holds what he desires
while we sit inside the darkened gallery,
hostages to her—a discourse
on abstraction (we watch him thirstily)

faint images on screens, equating this and that
in oils, deliberate calculus
(we're held as closely as a lamp
 to her strict cosmos).

But with a wine jug, the filthy
half-hidden man steps out of darkness.
What then of his delicious gloom?

Woman with a Coffee-Pot

The housekeeper scowls.

With a line drawn down her blouse
and skirt for girth and conquest,

the steel pot tall as an American

beside her certain silver spoon,
immaculate white cup.

The cylinders as loaded as her look,
as if she'd stand and strike us down.

Her hands outlined as heavy,
lethal with the teats of cows,

the well rope, thick-limbed husbands
restless in her soapy grip.

And for all that soft as fruit,

her breasts and heavy thighs, hidden
where his long eyes lead us.

Woman Strangled, 1870-1872

For ten years we have been
debating questions of art and literature.
We lived together, and—
do you remember?—often daybreak found us
still immersed in discussions.

Three men covering the one
without eyes,
 without a mouth

she floats aside with her skull
 violet, and billowing red

curtains blur over
 his ecstatic entreaties—

We realized that aside
from energetic, individual life
there is nothing but lies and stupidity.
Happy are those who have memories!

Eve

When she looks this way she lives forever,
brilliant in a crowd, hurling the flames
of lovers into throats, their coloured coats
atop long-legged stilts and jugglers.
No word for it but *dangerous*, her arms
etched with snakes and ladders
so you slip into a trance,
as fields of tourists and their children
fall in easily with thieves,
the streets alight with cries and cheers:
catastrophe, relief. Mouth full, oblivious,
she runs along a trail into the trees.

Woman in the Garden

Bring me another glass and another
filled to the brim with wine, and the grape can
stain my body, dye my skin until their vines
grow through my hair and my bare feet spill, like
spigots, gallons of a bitter stuff.
My whine that misanthropes interpret as their own:
leave me alone, leave me to my own undoing.
There are many ways to enter heaven.

Anna

In bloom she's a different flower
from the rest, thistle-topped, a showgirl strutting
mauve feathers from a prickly open dress

or with the arcing slender openness of iris,
as blue as a summer guest and
tough as tapered wire. As a rose she's

frivolous without arrangement, anything goes
with a rose. But as daisies spin on the verge
of roads, she haunts the traveller

cracked and rolling, the fields of crumbling towns,
her passing, blackened backgrounds.

"Give me the wings of faith to rise"

The man convicted
of manslaughter sits beside
her daughter in the church.
They sing from the hymn book
together—one turns the transparent
page, one has the spine. Their *Amen*
is harmonized, he holds the note
long after the congregation fades.
She watches her daughter
sit closer to him, gloved hands
like drowned, dark sparrows.

Self-portraits

The television screen floats up its icons:
a boy becomes a pint of rye, the orchestra

plays *Bad to the bone,* and invincible Vincent Van Gogh's
self-portraits blend together—the oiled eyes

hold a distant, shaming blue.
Wind-machines push all the crowds to one side:

the waves and the drowning. Each hour
insignias fly out, like doves from the ark.

I'm watching his eyes and the whorls on his face
become older, and what did he hold there?

Ironic Photograph of Lost Love

These dogs at the window, their adoration
of you, who loved
them and not me, at the heart
of a great mystery. Curious, led to
trails of pungent smells and
rustles in the dark, running woods, I turned
and carefully walked home. I mean,
can you imagine the danger that poses?

Here I'm looking inside with the mute
androgynous dogs and their wet noses.

The Screenwriter

I said *The car*, and gestured
out the open window of my room, *refused*
to die, remained on slick coastal roads,
blue carcass dripping sparks across the
hunchback bridges, open fields of
sodden crows and pumpkins, shuddered
low through forests, and along
the cliffsides. *By now it must be in L.A.*
I said, believing wrecks can come through Hollywood
like you, my friend, unscathed
if fucked up anyway.

The Hunter

His truck, big wheels and chrome,
always dirt-tired, and full of beer,

his brick apartment with the bear skin. When he
opened my bottles I knew he cared. He lit two cigarettes
with a thumb-flicked match,

could spot a deer through thickest trees.
When I asked about guns, he taught the difference
between shooting bottles and birds, and one night

fell down drunk by the bed, and asked
if I would rather watch wrestling, instead.

He knew the places owls called,
where the wide-boughed cedar
came rushing at the ground, where

the moon rose, holding over his crossbow
an irretrievable ring.

He found mountains and fast streams,
and threw himself naked into everything.

The Trucker

Those pancakes this morning!
and how the waitress pushed a little

with her tongue, faced
the man swinging out the door

to the eighteen-wheeler.
Well it was hot. But his back

was screwed on straight, cowboy hat
a little to the right. She swept

the change off the counter
into her frilly pocket, trashed the napkin

and flicked us a grin.
We ate it up with butter, syrup

and coffee: just another
sexist Texas breakfast.

Sore Love Lost

These sad old dogs of mine,
dalmation, setter, porcine corgi, and where the
mud splashed my feet near the last thin bean
are the fumes of their
unalterable stink, and love, and heavy breathing.

The Rider

He never settles for less than the crooked
helmet, the slouch inside a scraped wide rawhide,
limbs drawn up or struck for flint

against a heap of grass. Smoke first, then flame,
then quickly, all-consuming solitude.

Wedged in the shoulders where the bladelines
could be wings, a fury waits
as if something were taunting him, unfurling
just above the skin a warning:

for fear in the skeleton, the spikes
his cracked bones turn against. The twisted muscle

of a ride out of city onto plains,
 the sky a blurred wide empty—
for the redemption of his engines.

The Musician

In the sweet judgement of another
tugging snow from your blind eyes, fine

as a cokespoon, slender as a cross-knifed
crucifix, he was skeletal and

draped in skin as the young ones
leaving town from heroin. Without the leather

he removed for you, the writing scrawled
in scars across his back: the open

wounds cried what burst through:
at least, his name.

The Cook in Wilderness

The green bottles with their carved white lilies,
morning grease, all we'd eaten

from the bleak kitchens. The cook is most
unhappy, the cook is drinking, the

damned cook is feeding us each evening
while my old hopes flutter down

from the roof. The trees send out breezes of luck,
the clicking shrubs all shirking something, too.

*

Who goes into wilderness not believing?
In pines with their dark tops, men sit near

clouds for shelter stronger
than their final rapture.

Give me one mendicant who says
believing, you are saved. That faith

is in you, not in these charred shapes
striking an oblivious sky.

*

When birds leave here what they sing is fear
the cold will take them. But their song left

rustling in the last leaves
leaves him restless: there is no place

he has found, churning in the centre
of these huddling trees, where he cannot see

his brother burning in the eyes of others.

Landscapes

As if the water would answer, I go on talking.

— Sam Hamill

Sirens

All the neighbourhood dogs bark
when sirens rise through the empty skies,
and cars rush, and birds dart
over the construction site.
Hedges shiver as we brush by
and chalk appears on sidewalks,
our outlines of love, attempts and casualties:
the sweet and stinging bees sing in the grass.

Chestnut Trees in Winter

Hard or soft, coarse or tender,
the empty branch tips

with the light left around them and the torn
jagged peak beyond like the pit

of the stomach, fear, or an empty house:
a new approach to harmony.

Behind the wall and below,
better, is the pure green grass.

The painter reaches for the
hard white glint of snow

on the mountain, a pearl
where his shadow falls.

Fields

In daylight we appear out of nowhere,
walk into orchards, fields of dying trees.

The cooling lake is a mirror
reflecting sky to itself, the fallen

lie towards the earth, red and shattered
fruit: light breaks through outer

skins where birds pulled flesh
through torn openings, drew apple

from the shape in a flurry of wings
taken up in the air. The birds

leave us on earth with seeds,
imaginings. We can only listen

for the lake's insistent murmurs,
the torn fruit lit from within

with their own ruin.

We fall in the field

We fall in the field, in the dark
make snow angels, lying like children.

Then more recklessly we
hurl ourselves down, the whole field

littered with our instinct, how we
turned toward images of death

in shadows, in clouds hit
by arc lights scanning through the dark.

Illuminated bodies of clouds
swirled like dust overhead, disappeared

and in our hands we slipped apart.
I lay down, the impression

about my size, heat melting it larger.
What was once my body became an older

woman's, a man's: there were no angels
small enough for children.

Persian Gulf War, 1991

Waves

Over you the rough waves race their scars
and lacerations, and poplars bend to crack
their silver leaves in steely flame.
Names hurl through roses' heads, all tossed

and twirling, as the lake edge fills
with children: their hands slap sternly
at the water-mirror, passing grief
to green arms reaching up from sand.

Then over you the waves subside to brilliant
stillness, hands leap clear and I can hear
every child in his place, even anarchy:
the boats sail in to moor, rippling our

transparency, and their chains fall certainly
to the soft lush floor.

Water

The water strokes your back as
I would, quickly rivulets of

iridescent liquor
caress your throat, slick down

to your inner belly
and outside, my hands in their

quick and lighter tuning
chord your skin like an

instrument, across
dark silken hair, its

whorl towards you, inner,
outer world, a centre

so impossibly divine, human,
all there is.

The Paddle

Water from the paddle's curved end
spills on the smooth surface of the lake,
the drops falling back as we glide

through lilies, fish, turtles—their sinking
shells through the green—a release of the lake
back into the lake, perceptibly

joining itself from a brief
drop-from-drop separation we slip through—
Wet at the tip, warm

at the core, this is something
like holding you, holding a breath
in the stroke, a breath—the paddle's release from the lake

curved on all shores, it fills
every hollow with lake—you slide into the
grip of the paddle, your fist and your palm—

and the wood of the woods surrounding us fills
every hollow with lake, every
part of us, parts and fills.

Fragment from Li Po

A dog barks over water,
wet apple flowers have darkened.
Sometimes in the thick forest I watch deer,
near the stream there is silence at noon.
The blue sky is split by wild reeds,
a budding cliff throws down a waterfall.
I cannot find the priest.
Miserable, I wait in the trees.

Isolation is an Old Wood

1.

Fallen spruce spat up leaves secretly,
the moon crept through itself, a pearl
owls coveted. Arms flung back, the fisherman

was a bird stilled in flight.

I stumbled, batting with thick hands
the blackflies' lashing, until
courage gone, I climbed the steps, backed in.

When I drew nails from the
garden planks, wind over the lake
came sweetly.

Each nail pierced the air
like a calvary, colony
of aspirations, each

tiny spire. I pulled
the nails out, taking back
my last wishes.

2.

Then every colour and line had meaning,
everything was in its place, the tension between
an iron stake, its space beside the ironwood,

the old birds hammering, the empty oil drum,
green leaves spilling down
and smoke ran by on its own errand.

Then the sumac burned,
red torches held on each curved branch
like virgins' lanterns,

crossed leaves making
a ladder of air, and cedar
the height of a house swelled.

The velvet buds might have slaked
my thirst, but I didn't dare, eager
for the rain.

Then I dreamed each tree's wasted personality
(brilliance that bolts too soon from beauty
to fear), and the trees changed.

I could have shed myself
and—with the featherless birds
that fell from nests—the voiceless

might have found their breaths in mine.

3.

I waited for the eagle and it came by
above the hill, an unfixed crucifix,
soared into the hearts of trees.

In the garden was the eggplant gleam,
a fishy eye: leaves
curled and flagged, but the fruit's

black flesh hung steady, accusing.
Some rotted, autumn in the garden:

leaves clutched the ground, mourners
at a funeral, crowds of grey coats.
What few fruit were left lay

hard on the ground.
The soaked skin had split
to withered flesh, the stalks

broken. Where green leaves had lulled
with their promise was dead grass, bristled
skin of men. White mushrooms

pebbled up regardless, the rain sending scores
among the scarlet chard.

4.

Who, among the stars, would hear me—
but only poets read old poetry.

What I thought were dogs
were owls, their calls

across the white
lake at dusk, blurred
by fog and echo.

I was there after the sun
slid brilliant into a scree of clouds,
hearing the hunting cries,

my own, and that wind, a long moan
roaming over pine trees.

Landscape with the Gathering of the Ashes

You cannot see their faces
in the dark outline of trees rising

to a coloured mass: fury, individual
as leaves, consequential

as an upturned gaze. The small men
on the church roof as needles against

the rock rising into purest windblown sky.
In the buildings, all our empty doorways.

The strongest columns of the church
in league with trees, you know I always

turn to nature out of grief.

Sunflowers

Marvelous stalks
raising studded beds
of seeds,
hundreds of souls
prostrate
in rows
attached
to centre.

Birds fly
expectant
around the yellow
wings, eye
split casings
torn from the
seed heads.

Separating faith
from the
faithless,
sagging
with their silent
raw weight.

A Koan

A koan only goes as far as it goes, but a life—
there you have a mystery. Karma like the

sins of the fathers, unravelling generations,
early birds and greasy wheels. Give me the old

wooden chair out on a porch, I'll show you
crimes and regret. Rust-chested robin

is the last to know, out strutting in the rain,
where the true meal lies. The writers' long hands ache

from their tugging at the ground. You could
stand up from the rocking and walk away

or take it all to heart and leave them
gaping, open-mouthed.

Snow

These words like flakes, the muse
of snow space. What's between them
as they drop to earth? A silence

before impact. The radio gives off
signals of flight, possible
explosion. Helicopters circle
in the always night

of arctic winter. A pilot
down there hears his breathing,
hears his heart, hears nothing
but his lost self, craft

without tassels or light.
Words from an open mouth,
jumbled morse of snowfall.

The Fall

In the sky sails by Daniel Boone's coon hat
in a fast high wind from the south

and my mouth sore from breathing and winter
coils in my skull, freezes solid for weeks

and my cheeks, too, sting with a northerly
dread of it. So unarmed for cruel weather

I descend into what I imagine a dream:

the clouds only hang there, still as
a painting of the new world. Constable is

skying with a pleasure that ignores
any break in the mind; in the skin or bone

there could be no bleeding. All we're seeking
is a warm light, even dying. The cold wind—

you know, *dead men naked*—grabs us from below.

Clouds without heaven

Again the presence of them overhead, less
sound than a child's breath
 but more bold
and speaking loud of what, our imminent
end? Where we once gazed, saw a mass of shapes

and tales in days of lying on the grass,
now should be a curse, blank canvas, waiting

for the word.
 Are we damned to see the earth
demanding shape from all our muttering,
this falling into spring, proof of our

dissolution, these attempts to draw
spirit, ignore death?
 Let my breath
bring words that won't dull my soul with
mockery, dishonesty. This world is
 falling, failing,
and we the guilty merchants set to flee.

The Lovers

The imperfect is our paradise.

— Wallace Stevens

Constellations

The waves poured in from the west, shifted
sand along the shoreline, the wind

on your face left you unmoved.
Change was the enemy.

What shifted east
through the night was our

will to love, the constellations.
Birds slept with their wings

bent inward, covering the rapid heart.
If you saw me you would

know I had no motive,
in the stars we make our own desire.

Who abandoned you was your own,
torn self.

Things That Are Taught

He gave me silence, that much
is certain, though trees and a woman
playing piano for the sake of her
fiancé became part of the scene.
She rushed through mountain
rains and fallen needles, the stark
certainty of above the snow line
and below. Crows gave him
messages, or were they ravens
with immeasurable range. The forests
and their cumbersome, hidden lakes;
one winding road up there
famous for its indecisive
wildlife, the sonatina, unbearably
that drew him in. I was just there,
you understand, to listen.

A Cloud No Bigger Than A Man's Hand

Swept cumulus is actually ice
crystals falling, he said
one evening while she, underneath
the rustle of trees, heard
a big animal moan.

He leaned over the fence.
She, on the other
side, heard stars
twist towards them, felt
claws scratch cloud.

He would not walk
on edge.

She appealed to him
but only slightly, before
she stepped back, leapt
on the fence, crouched bone and skin.
A feel for balance,
wood clutched between her fingers.

The Visible Man

Watching the eyes is deceptive,
red-ringed or white as bibles,

one could never say clear. You see him
love you, but then he appears to be

water, nothing like
the strength of leaves in a wind, nothing

like the ground covered with grasses,
nothing like the mass of oceans.

More like rain
spilling from a bowl left out,

a caught, obscure reflection.

Kaleidoscope

We twirled our patterns of nipples
and noses, curves of the brow
through cut mirrors,

we played the space between us with
shattered light, held hands and viewed
a hundred images of hands, the room

bursting into demonstration: your foot
above the red carpet, a crowd of boys
and their final steps, my lips

a snowfall falling towards you.
A whole room full of bodies, exchanging
waves and glances, slipped from us,

and we plunged blindly into the dark.

Honey

Sometimes we come
straight
unfold aloud
like honey
down from the knife tip
fall through a thought
without a thought
and in falling, spin
translucent self to bare
thread, gold line
to bread
where we lie
tangled, melting.

Apple

Every bite I take of the green
apple is tainted with dread: the wizened
entry on the other side, the tiny
brown hole. My teeth sink in, and I
examine what is left, expecting
a body, colourless, to stand out
from the flesh. What shouldn't be there.
I watch your face every morning
with amazement. You drive me
to the edge of the cliff the road takes
a swift turn away from. When I
foolishly lean from a window
you hold all my weight.

With The Hunter In His Trailer

Because I knew nothing of his world,
and he asked, because his line cast
across rivers drew salmon and trout
dripping at the table—
elements he knew, of the wet
body, hair-trigger shot
of the rifle—because his pride
was clear, my ignorance and love
could be blind, as they say, and who needs words
in the dark, twenty, and trusting.

Hunger

I drew you, lines of your soft cock
and my single, separate hand.
 Each finger crooked

upward, open palm.
Asleep you were a child, dreaming,

while across the lake a small boy called
to his father, *I'm doing it, can't you see?*

splashing water, brief applause
for the afternoon.

 Your face turned
at the small voice, waking
into a flat, lost apparition.

One Hundred Insects

After years he shows up in dreams,
a glance more frail than a paper screen.

Perhaps ants still fall from the ceiling,
and branches stroke his building

ceaselessly, reminding wood of its
green source. What left us

hungering for dusk and filled the hours,
deaf to a grief we'd never hear

again, in the fields the rustling.

Correspondence

There is this room and the rain, the
attempt to understand your message.
A window I'm listening to, its
shuddering sound like the hands
of someone bound and beating on iron.
Ship's blast through the trees: but these
pages fold and unfold without telling.
Someone caught; someone returning.
All you have left
are these tiny luminous letters.

Brass Bowls

In the image of bowls
is implied sound, and their openness

a rung bell, a shuddering tone—
all the vessels hold this repercussing

emptiness, removing thoughts, appearing
to replace things in a strange

desire, change, reaction
to something simple as

the falling rain: still, at heart
our hollow, holding selves.

Dreaming Cormorant

In the dark your face, hidden
under blankets as the thoughts

beneath the lake's star-blurred
surface, appears subtle

in a prayer of dreams, a wind
beneath the door—we could be

sleeping in a northern inn
snow settling on the roof

we could be sailing open ocean
the wavering of breath our

phosphorescence, wake
a prairie, scrolling

fields of yellow fields
unrolling sheets against the

fence posts, ripping
softly, snowy cormorant ascending

on the oars of its wings—
and our thoughts as we are sleeping as we

fall against the earth again
rise, smoke, to the ceiling.

Calls

Still hanging on our voices,
phone lines, rattle of your work's radio
in the background. I want to touch your ear,
flick liquor from a cup in your direction,
lick the trail from temple to chin
and coil up in your beard, a tight spring.
All this stroking, stealth,
our whispers—the lines are fine
copper impulses. But someone needs you
at the other end, your voice fades
through a clash of plates, through hiss,
you miss the low trill of my throat.

Chickadee

You wake by the blue light
 chickadee on a branch, its
quick black and white mask
 shifting through apples
and leaves. Then you hear
 the rumble of garage doors:

my bike rolls out of the dust
 engine fires
and there's me in black
 leather, white grin
kicking in the gear
 —what a chick—

wishing the quick
 spit of gravel.

Swimming

Every poem is a love
poem, slipping
between branches.

He led her on
to the watery clearing,
grass rising

through reflections of
pregnant cloud.
She said *you look*

like someone I knew
lifting her shirt
to reveal breasts

of coral, the small
coloured fish
swimming quickly.

He dipped his body
toward her, not knowing
how deeply

close she was.

Oceans

The seas screened
by my thin curtain of skin.

Who watches from within,
whose slowly focusing grey eyes?

*

Out there, accused and victims; while
inside, the passenger smiles, in

perfect exile. The nudges catch me
unaware, punchlines

to jokes I never hear.

*

My silhouette in winter: tweed
to the throat, a grey

lifeboat on sidewalks.
Alfred Hitchcock
 in a shop window.

The crowded buses jerk long
 conga lines of generations home.

*

The heat never varies: I'm cool
as you want me to be, bathed

with never a grave thought in there,
taut, dark cocoon in a small sea.

*

I wait quietly
by the stream, dream all this,
make my swelling shape a glass
where worlds appear.

*

Then his face and his
 long warm curves,

the blue water of sleep
eluding all but the baby. His

eyelids flutter, eyes
 pulse with the moves
of the inner theatre, the smooth

soft brow revealing nothing.
A small hand between the lips
 as if wondering.

*

Will he hear
streets as water, waves
 in the chimneys, and pigeons'

sighs as if ocean cries,
 the winds against our
 ragged coastlines raging?

The River

My bare feet next to your
leather shoes. Sometimes I fear
words will leave me, that
I can only dream of them.
But something
hovers around me, seeks
a voice as well: the world speaks.
Beside the starving child
is a blade of grass, beside
the drowned man, the river.
I can't call either *anguish*
or *beauty*. Your face
in expressions of rage
or ecstacy. What I mean to say is
love, the fire is burning everywhere,
come away with me.

Acknowledgements

My thanks to those who gave good advice and who threatened tattoos, including Steven Heighton, Mark Sinnett, Eric Folsom, Janet Madsen, Cathy Stonehouse, Mark Cochrane, and Barb Parkin, and for their generous support, Keith Maillard, Daphne Marlatt, Don Coles and Al Purdy. Thanks also to the Ontario Arts Council, the Canada Council, and the Banff Centre, and to the editors of publications where some of these poems first appeared: *Arc, Canadian Literature, Dandelion, a discord of flags, The Fiddlehead, Grain, The Last Word Anthology, The Malahat Review, The Moosehead Review, The New Quarterly, oh baby shrapnel, Poetry Canada Review, Prairie Fire, Prism international,* and *Quarry.*

The last line of "The Fall" includes a phrase from Dylan Thomas' "And Death Shall Have No Dominion"; italicized lines in "The Cook" are from Rombauer and Becker's *The Joy of Cooking,* in "Woman Strangled" from a letter by Emile Zola to Paul Cézanne, in "Water Maidens" and "Untitled" from Cézanne biographer Hajo Duchting, and in "Isolation is an Old Wood" from Rainer Maria Rilke's "Duino Elegies."

Mary Cameron is a former editor of both *Quarry Magazine* and *Prism international,* and has been published in *The Fiddlehead, The Malahat Review, Arc, The New Quarterly, Poetry Canada, Canadian Literature* and other literary journals. Her work has been anthologized in *The Last Word: An Insomniac Anthology of Canadian Poetry, A Discord of Flags: Canadian Poets Write About the Persian Gulf War* and *Altitude: 25 Years of Writing From The Banff Centre.*

She received her Masters degree in Creative Writing from the University of British Columbia and studied at the Jack Kerouac School of Disembodied Poetics at the Naropa Institute in Colorado. She spent her childhood in Malaysia, Brazil and Vancouver and currently lives in Kingston, Ontario, with her husband and son.

Author photo by Chris Miner.

www.ingramcontent.com/pod-product-compliance
Lightning Source LLC
Jackson TN
JSHW011951131224
75386JS00042B/1665